ART ANTI-ART

Signature Series

ART ANTI-ART
Anartism Explored

by

HÉLÈNE PARMELIN

translated by
J. A. UNDERWOOD

Marion Boyars · London

A MARION BOYARS BOOK
distributed by
Calder & Boyars Ltd
18 Brewer Street
London W1R 4AS

First published in Great Britain in 1977
by Marion Boyars Publishers Ltd
18 Brewer Street, London W1R 4AS

Originally published in France as
l'art et les anartistes
by Christian Bourgois Editeur

ISBN 0 7145 2570 7 Cased edition
 0 7145 2571 5 Paperback edition

Printed by Unwin Brothers Limited,
Gresham Press, Old Woking, Surrey.
A member of the Staples Printing Group.

Something extraordinary is happening in the world of art. The situation, which was already strange, is now approaching a bizarre climax.

It is a situation where anything goes and all is forbidden, where everything is both open and closed, teeming with life and at the same time in the throes of death, a situation in which art has every right, is losing its every means, and is discovering other means. It is praised to the skies and thrown to the dogs. It is made out of every conceivable material, and out of nothing. Its 'revolutionaries' are innumerable and form innumerable opposing camps. They repudiate it, they leave it to the bourgeois, they hail it as their father, they supplant it, they execrate money and they make a pile. Non-art proclaims its *raison d'être,* art the reason it should cease to exist. The 'cultural guerillas' have pronounced the era of commercial galleries and museums at an end; they want to strew the city with neon squares for all.

And all this—exciting, pulsating, exasperating,

5

fecund, a perpetual prey to perversion by the tongues and pens of some and the money of others —all this would present no problem at all if only people would call a spade a spade, neon neon, objects objects, emptiness emptiness, decoration decoration, and so on.

But a mammoth process of falsification—of words, ideas, meanings, ends, and means—is under way. Revolutionary ideas about art and society peddle, in the guise of 'art for all', the manufacture of decorative art by industrial firms. And the torch torn from the hand of the bourgeoisie has come to look very much like a sectarian struggle for supremacy.

Fields of unlimited potential, as yet hardly explored, have opened up around and outside painting and sculpture. Some are scientific—the field open to those who work with electricity, the possibilities of collaboration with electronics for those who dream up light-ideas, the use of computers in all kinds of lighting techniques and techniques of urban decoration, extending to the level of the most advanced urban applications of light and the most futuristic light-shows.

Others are semi-scientific—geometrical decoration of the most abstruse and elaborate kind, in conjunction with architecture and the whole gamut of currently fashionable environmental thinking.

Others again come under the heading of anartism of the most absolute kind—the whole merry-go-

round of ideas that spins to the music of 'Anything Goes', manifestations of ridicule from the most earnest to the most eccentric, anartism as spectacle, the anartism that takes itself seriously, and, to crown it all, the ravings of some of the most skilful word-jugglers art criticism has ever spawned.

The greater part of the inhabited globe is caught up in this climate of frenzy in which painting and sculpture have no place at all. It is more than a merry-go-round; it is a whole enormous fairground of ideas rational and irrational in which everyone may find his vocation, his happiness, his fortune, or his misfortune.

It is a period of the most tremendous international excitement. Or rather it might be such a period if it were not for the fact that everything is warped by this idea that painting and sculpture are dead and that anartism in all its forms, having taken their place, constitutes the artistic avant-garde of our time.

On the one hand we are told that only scientific and semi-scientific techniques are worthy of the name of avant garde, because they adjoin science and technology. On the other hand, anything is worthy of the name of avant-garde because it has been so named, godfather creator and godmother critic baptizing as 'profound thought' the nothing that is presented at the font amid peels of organ music.

All this might appear to have some connection with the great debate which is going on at the moment, in which culture as a whole is being called into question. Not a bit of it. Art, anartism—these

7

words mean money. There can consequently be no such thing as pure controversy in this domain, except possibly in the minds of one or two individuals.

But when it comes to proving that art is to be done away with and anartism enthroned in its place, the vocabulary and ideas of controversial challenge come pouring out. They would have us believe that anartism is a philosophy—nay, a social morality. They would have us believe that the avant garde is the brand-new product of the ideas race. Never mind if it lasts no longer than a fashion; if it sells it is immediately backed up and cracked up and stamped as official. Up with ideas, and down with thought!

For thought, read painting and sculpture. Past it. Not modern. Has got to go. Modern is defined as 'suited to our time'. So it's the square in architecture, explosion in the environment, and Dada taking itself seriously. They reject the galleries, but continue to occupy them. They reject museums, but still demand a place in them. Speculation they decry, while replacing the dealer with the industrialist. What they want is art in life, but instead of open spaces and streets being available to sculptors and walls and facades to painters, little metal plates are set tinkling through the city and (shades of Malevich) little white squares set dancing on big white squares. Non-art is everywhere brandished in our faces. Negation is all well and good, but when everyone does it, it becomes as academic as anything else.

There are quite a few countries that have never been very strong on painting and where the

florescence of the square may achieve unheard of splendour. Up to now France has been a bit behind in the field of anartism, and has been severely criticized for not getting in step with the times and putting anartism in the Musée de l'Art Moderne. It's coming slowly. They are making up for lost time. How could anyone be so naive as to think that this land of painters might be the only one to make it possible for painting, sculpture, and anartism—rational and irrational—to exist side by side? No, we're with it at last.

Today, then, we are nearing the apex of a process of escalation in which the chief accomplice is a certain kind of art criticism. The events of the last few years would suggest that this criticism has claimed as its own every absence that ever needed filling; absence of thought, absence of research, absence of creatitivity, absence of knowledge. And above all absence of lucidity—and of humility.

The least little painter who picks up a brush takes himself for a demiurge. Artists void and annihilate, campaigning in nothingness and disappearance, driven on by a climate that favours the grand gesture Critics specialising in anartism—helped out by all who succumb to what they say—stuff this void of nothingness with their words and those of all the propagandists of 'science-art' and what amounts to a kind of universal woolworthism. Creators invent and innovate in realms of fascinating interest outside art. The critics immediately fill to overflowing with

philosophical significance, moral courage, social implications, originality, 'back to first principles', and all the other verbal and mental ravings contaminated by the currently fashionable pseudo-philosophical or pseudo-scientific jargon the yawning absence which is the 'avant-garde' in its latest manifestation.

As a result, the creators of anartism start talking themselves more and more seriously. They begin to talk like the critics themselves. The critics have perfected an inimitable language which defies parody because it is itself, unconsciously, a parody. Their praise and enthusiasm, together with the others' contentment at seeing themselves thus solemnly placed on a pedestal, form an ascending spiral. Neither Rembrandt, nor van Gogh, nor Cézanne, for all their assurance, ever talked about themselves with the extravagant self-confidence that characterises today's anartists. Or most of them. They put themselves up as the brilliant, the undisputed avant-garde, sweeping aside the whole of art with a wave of the hand. The critics go one better. And so it continues.

In the end there are no more artists. There are only geniuses. It's too much; particularly as there are some marvellously inventive individuals among them.

So on the one hand we have the manufacturers of giant lampshades and large-or small-scale theatrical décors, the begetters of non-work works, of

paintings painted or not painted, objects present or absent, and all these expressions of either the impossibility of painting or contempt for painting or an obsession with technology or the clowning of the whole anartist circus: the refusals, the surfaces, the things as they are or the things imitated, the limitless resources of material and the inexhaustible possibilities of electronics.

And on the other hand, instead of commentators, judges whether good or bad, or chroniclers, we have a body of missionaries charged with persuading the world that there is more glory, more philosophy, more meaning and modernity, more lust for life and more superb renunciation, more love of mankind and more hatred of society in an arrangement of black and white squares, in a piece of metal or rubber, in a steel and electric sign, in an abstract environment, or in a 'simple block of wood', than there is in an El Greco or a Picasso.

The fascinating thing is that it is all being born and teeming with life and wiping itself out all at the same time. It is genuine, phoney, fashionable, poison to some and the meat of publicity to others. It is just and unjust, modern and as old as the hills, young and blasé, stupid and smart, selfless and self-seeking, intelligent and attaining a new high in cretinism, full of transparent tricks and good intentions.

Moreover a terrible fear haunts the world of the arts and non-arts. Because if you are not uncondit-

11

ionally with the avant-garde you find yourself consigned to the same catalogue of imbecility as abstraction and figuration, the Salons and the Institute, a casualty of easel-painting fit only for the Hotel des Invalides; you are the boredom of the museums, the phoney smell of the *vernissage*; you are for Buffet and Lorjou—in a word, you are ripe for the rubbish heap.

The militant representatives of 'non-art-for-the-people' are indeed nothing less than fanatical. The whirling dervishes of anartism are blind to everything except the ideas to which they have pledged themselves. Or, if they see beyond them, they see only enemies. A certain imperialism, even terrorism, characterizes their writings. What they affirm they also affirm they are right in affirming, and this would seem to be adequate argument for converting us to their arguments. Their tone is imperative, their language lordly—that's the way it is and no questions, this is the avant-garde speaking, this is genius speaking, and if I say it's so you can take it from me because I'm an expert.

Exactly the same thing happens every time a new 'avant-garde' emerges. The critics rave and the artists stick out their chests. The new 'avant-garde' tries to mow down or sweep aside everything standing in its way. The colossal academism of negation proliferates. For their protest against this rotten society they demand all this rotten society has to offer in the way of official backing, museums, and all the other resources available to the creative artist.

What they are trying to change is the whole notion of art. Instead of turning their attention to something which is in the process of emerging, for which a suitable name has not yet been found, and which is either pleasing or not, useful or not, they are attempting to replace art with all these things that shine, embellish, move, fill, empty, amuse, disconcert, evoke life or evoke nothingness, adorn, enliven, or rationalize.

They pronounce art dead in the name of all they want henceforth to use the term for. Instead of declaring the scope of plastic or non-plastic exploration enlarged, instead of applauding the emergence—alongside and outside painting and sculpture—of a thousand vitally interesting and mentally stimulating activities ranging from the cozy (and let us hope temporary) little vacuum that the disillusioned young painter pumps out for himself to large-scale sound-light and light-movement environments controlled by computers, instead of adopting a policy of 'every little helps', they seek yet again to anathematize painting and set up in its place all kinds of foreign techniques.

The attempt has now become universal, promoted on the one hand by the official international media and on the other by the devotees of neon or the square, and by those who aim to submerge an object in its 'environment'—if I may use such a word at a time when it has become the panacea for anything and everything.

Take a student who wants to go to Vincennes,

for example, to find out what he is letting himself in for in electing to study a particular branch of art. He brings back a sheaf of forms to fill in.

I quote an extract from a Vincennes 'research project'. 'Analyzing artistic activity, the commission notes that the unifying factor behind the various manifestations of this activity lies in sensory perception. It is on the basis of this sensory diversity (sight, hearing, touch, etc.) that we would classify the various artistic options. So let us stop talking in terms of music, theatre, the plastic arts, cinema, etc., and talk rather in terms of the visual, the aural, the tactile, the gestural...'

After this solemn and moving affirmation, let us get to the point: 'Gestural and tactile experience and knowledge determine all perception of aural and visual phenomena. Art is movement.'

Development?

'Optical research. Kinetics. Lighting studies. Mobile expressions in light. Evolutive chromatic volumes.' Etc.

This is only a research project, seeking only, on its own admission, to better and complete itself. But then art was never anything else.

Some time ago, in 1967, a *Biennale* of Art and Anartism opened in San Marino. Exhibited there was all that one might wish for in terms of shapes, inventions, pieces, neons, still or moving objects, constructions, asculptural sculptures, environments, metal, string, plastic, polyester, etc.

In a neighbouring room Italian motor manufacturers were exhibiting car-bodies, whole or in part, headlamps, chrome fittings, paintwork, all magnificently set out and pulsating with dynamism. And what cars they were!

As objects—even if they did possess the dismal property of serving a purpose—there was no doubt that the car-bodies carried the day. This was pointed out by more than one critic. Here was food for thought about the modern world.

The prize of the *Biennale* went to Pino Pascali for his pans, later exhibited at the Paris *Biennale* with the title 'Still Waters 1967'. The work consists of a number of shallow vessels resting on the ground. They look like tinlids with the ends flattened down to make them join together, thus forming a kind of rough channel. They are filled with water (and also with whatever the visitors happen to chuck in them).

Something for the children, in short—an environment for floating paper ducks in.

Let me go on throwing out examples and ideas. I'm building up my . . . environment.

A Milan gallery—a gallery of painting, that is—exhibited the front and rear, bright yellow with black on the doors, of the amazing Lamborghini-Miura. The car itself. In the gallery itself.*

What was it—a futuristic object, or the long-awaited nuptials of art and life? This is a key point

* Mentioned by Georges Boudaille in *Les Lettres françaises*.

of confusion. If the artist exhibits a 'No Entry' sign, all nice and red and white the way they are, what is it? Life in art? Art in the city? The city furnishing art for the galleries? The artist drawing attention to the street-object and, by isolating it, giving it its force? Charging it with some fluid by taking it out of its street-context?

Either the artist lends his gifts to the task of animating and 'vivifying' the various elements of the city—than which nothing could be more desirable. Or else he takes the elements of no matter what and uses them to make an impact on the spectator's mind. Why not? All right, but why?

If J.-P. Raynaud chooses to exhibit at the *Centre National d'Art Contemporain* a number of gigantic empty geranium pots capable of holding twice as many thieves as Ali Baba's jars, why not? It's fun. But why should these pots and elements and signs and so on be 'psycho-objects'?

Obviously it sounds a lot better and raises the conversational tone no end to talk in terms of 'elements of the urban alphabet' rather than simply saying 'No Entry signs'. But I find quite seriously that they have lost their prohibitory power . . . You can say what you like about them. And people do.

All the papers went on about Raynaud's 'obsessional series' of flower pots. I know he used to be a gardener, but why on earth not let this young anartist, who is so full of ideas, go on working in the kind of solitude that favours such activity? Hardly had he taken up art—or non-art, or 'psychoobjects', if you insist—before they were showing a film about him because he was representing France

16

at the São Paolo *Biennale*. I refer to the *Biennale* of painting. It must have changed its name since.

There was general indignation because at the age of twenty-eight he had still not had his official exhibition. He has now. Like I said, France is with it at last.

And why not? Everything is valid as long as we do not go around crowning with haloes people who are not saints, nor fill with the language of criticism pots which are purely and simply pots albeit big ones.

Here is what Gérald Gassiot-Talabot wrote about Del Pezzo and Raynaud in *Opus* magazine: '. . .When Del Pezzo places on top of a pressing in the form of a bath-tub on end a multicoloured light and the name 'Marat', when Raynaud sets up in the middle of the Galerie Fels a swimming pool filled with a red liquid and fitted with a gauge, they are both of them transcending the fetishization of the object in order to amplify a field of resonance, extending certain lines laid down in their earlier work to the point where meaning and plastic necessity reach a kind of frontier beyond which the artist is entering the search for univocal communication and erasing the margin of inexpressibility which is his province. . .'

He also said Raynaud's objects were perverse, 'bearers of evil testimony in which cruelty, suffering, oppression, and abandonment to the blind forces of insanity and murder are as it were codified by a gardener of disturbing gentleness and good manners'.

I could never get so many things into a sentence, let alone into a flower pot.

17

At the *Salon de Mai* not many years ago the attendants were busily unpacking canvases, sculptures, and objects for the exhibition. A chair wrapped in paper was duly unpacked and the paper removed. Then someone started tearing his hair. The work as submitted was the chair *in its wrapping*! It was hastily wrapped up again.

Why not? But as regards enthroning in that chair the aims of the avant-garde, creative discovery, challenge, the shape of the ambient emptiness, and a symbol of modernity, for all the critics' tremendous suit of clothes the chair and its wrapping paper were as naked as the Emperor.

But in the climate of today this story has a stale, old-fashioned ring. It belongs to another world. Anartism has spread its wings since then with a quite different vigour and inventions of a much more astonishing kind.

A younger generation, restless, tormented, bursting with problems of vital importance, greedy for fresh ground to take by storm, has invaded the field of anartism with a raging appetite for discovery. Sometimes, too, with a no less raging appetite for publicity, controversy, and quick success, cultivated with the greatest care and application, with much scurrying in the corridors of anartism to be the one who enters for the *Concours Lépine* the spectacle that is going to draw the crowds, or get itself talked about. Is youth, then, in this field, a positive virtue?

It can only, with very few exceptions, be a virtue

18

with anartists, or among the artisans of non-painting. In art it has never been a guarantee of greatness. (It is not every day you get a Géricault painting *The Raft of the Medusa* at twenty-eight.) Painting and sculpture are spheres in which freedom is fashioned by quantity of research and labour, by process of accumulation, by time. Art requires an endless period of maturation.

The *Salon de la Jeune Peinture*—formerly for the under-thirties—is the proof. People always find it disappointing. It always comes under attack. But this is perfectly natural—this is youth feeling its way. People are wrong to pronounce such categorical judgements about it. The interest of the Salon is precisely that it gathers together minds which are in process of formation, among which something may or may not stand out. Great art is a question of time.

On the other hand, youthfulness enlivens in the happiest possible way, for example, that vast ideas-bazaar which is the *Biennale des Jeunes*, in which painting and sculpture always find themselves at such a disadvantage. Because not only do they betray their age, but all the amusements and mechanisms and neons around them create a bustling atmosphere in which what is looked for is inventiveness, the trick, the idea.

You can find everything there, from the slickest to the most ingenuous. From balloons that float off into the air to the most complex geometrical mazes of electric light. From environments for nothing to environments for architecture. Rubber people bouncing about on beds, transparent plastic cages in which vague objects move about, panels on which

19

everyone is asked to write something, lumps of sugar suspended on strings, enormous Japanese pillows, and all the curiosities of neon, noise and movement.

Squares, geometries of all sorts, electronic light, so-called cosmic vibration, polyester and crylon, dress-objects, convertibles, laminated wood, mixed-technique sculptures controlled by transistors, fibreglass, copper plates treated with explosives, polyester resin and hemp rope, fluorescent paper, stroboscopic projectors, ribbed glass, inflatable structures, unnameable things crawling along or up walls, models, humour, science, nothingness, crazy architecture that may some day serve some purpose, a marvellous mixture of anything and everything, a whole astonishing emporium of ideas. Rich and poor. Subtle and naive. But the painting exhibited is non-moving, non-luminous, non-functional, etc. Painting needs animation, of course. But not the sort provided by motors.

'Painting is dead.' How else but with these words could Otto Hahn have begun his preface for an exhibition of 'objective art' in the spring of 1967?

Among the exhibits were a pair of ironing-boards. Signed. A little gun mounted on tyres consisting of more wood than metal. Also signed. A half *trompe-l'oeil* wardrobe made of 'plexiglass and guillotined posters'. A raincoat stuck fast to a piece of formica, etc.

I quote: ' . . .No more brushes, no more painting, no more eye, no more hand, no more play of materials, no more feeling, no more personality! No wonder the adepts of traditional art are terrified . . .' Or this bit: 'The artist's hand is invisible, and his eye impossible to localize. The art of representation has been replaced by an art of presentation . . .' Or this: ' . . . Literal, factual art, physical art, an art of collage, of assembly; the illusion of the event is replaced by the event itself.'

And to finish: 'The more this Objective Art emerges, the more it reflects the great turning-point of twentieth-century thought: objectivity and the acceptance of artifice. What men want is not impressions but facts. Facts furnished by a system: economic, sociological, psycho-analytical, statistical, photographic . . . Man in search of an authenticity in accordance with Nature and the Cosmos has given way to man finding harmony in the artificiality of the technicological, industrial, mechanized world, finding pleasure and beauty in the products of synthesis and substitution . . . Science today is creating artificial means which will soon consign Nature to prehistory . . .' And so on.

Furthermore, every act of 'matter-as-such-for-sticking-thoughts-on' is and will be regarded as an essentially modern act in an advanced industrial society.

Never mind who does it, never mind what he does—the great and wonderful process of adaptation to the 'technological universe' is under way. If we would raise ourselves to the level of the scientific climate in which we live, let us baptize each everyday

object with the name of significant work. Let us knowingly live in this world of ironing-boards on the walls and giant flower-pots on the floor. In the universe of things. Things aren't enough for us where they are. They have to be taken and put under glass.

An artist by the name of Nikos produces ingenious and extremely interesting montages by enlarging silhouettes on to a canvas screen and then photographing them through a piece of transparent material. Actually the process is more complicated than that. But the results are amazing. Nikos obviously has nothing at all to do with what Restany writes about him. At least I hope not.

'Nikos's look is that of the psychologist who traps us in a particular gesture, not to say in a particular word. Surely the sensitivity required by a Rembrandt or a van Dyck to capture the flash of a smile or the line of a wrinkle was no greater? . . .'

Or: 'This Prometheus of electrical fire expresses himself in and through light, wielding his spots as if they were brushes, modelling his shapes, recording them on film, and reproducing them in large-format prints. Gone from his studio are the smell of turpentine, the oil stains. What comfort, what progress, the pleasure of it! . . .'

Or again: 'The baptism of the object, while marking a return to a new folklore, is an initial reference implying the technical demand for its own eclipse; borrowings from contemporary sociology

and technology must of necessity find articulation in a language of increasing simplicity going beyond the gesture of appropriation . . .'

And finally: 'What we are witnessing today is the generalization of a problem of language based on the insertion into expression of a sociological relay. This is the prime phenomenon. Anyone speculating on a rehabilitation of figurative painting by way of a modernization of subject-matter is making a big mistake. Easel-painting has sunk pretty low when it resorts to narration in an attempt at survival. An ice cream *à la* van Gogh is a poor reply to Oldenburg's imitation-leather steak. . .'

Claes Oldenburg produces fake food. His studio is like a delicatessen shop, with shelf upon shelf piled with plates of food and special dishes. He has made a soft typewriter, 'chocolate and sausage éclairs', bananas, and meat either sliced or in joints and arranged on a dish. He works surrounded by rows and rows of non-perishable foodstuffs prettier than, but otherwise very much like, those you can see lying in refrigerated shop-windows.

Claes Oldenburg is an astonishing character. Listen to him (October 1964): 'My ice cream is an illusion of ice cream. I am not trying to imitate but to create a lyric situation. My work is the objectivization of my relations with the world . . . When I was making pancakes I started by using painted canvas. Then I mixed sand with the paint. I ended up using a plastic tube. Each time I had to balance

23

the different changes: as I worked I was readjusting my vision according to tactile sensation . . .'

He also makes giant peanuts. And he lives among these simulated foods, these climates of thought, these strange associations. He says, 'I am trying to rediscover certain elemental forms which are as it were the certainties of the universe.'

Otto Hahn, author of the interview with which the catalogue is prefaced, asserts: 'Seen in this perspective the sculptures on the shelf offer themselves in a new light: in the Italian cakes we see a Doric column . . .'

Why shouldn't Pavlos exhibit six segments of an orange in plexiglass? Why shouldn't Clive Baker exhibit 'Van Gogh's Chair' made of chromium-plated steel? Why not exhibit the object itself? Or its appointments? With no change? Or stuck to, ground down by, backed with, broken in, etc? Why not?

Sometimes you find lovely ideas at these exhibitions—ideas that make you laugh or almost cry. But by and large there's something rather dreary about Things.

There is another kind of anartism, more spring-like.

In 1966 Pommereule exhibited at the *Salon de Mai* (with masses of photographers in attendance) a peach tree in a pot. To quote Pommereule: 'I adopt

objects from reality because reality is fascinating and it is quite superfluous to reproduce them in painting. I regard the laboured production of a work of art as an empty, obsolete gesture which is vigorously refuted by modern society and the human condition today.'

It certainly was a pretty peach tree. Prettier—he was quite right—than any reproduction. But as for seeing in this gesture something magnificent, revolutionary, world-shaking—well, we have been just a bit too spoilt in this connection. We find nothing more natural, even historical, than nay-saying. We have had it all. Dada here, Dada there, Dada everywhere. From Bruni's 'burst cement barrel' in Moscow in 1917 to all the rest of it ever since—in every field.

Another essential, although obvious, point lies in the fact that in capitalist societies art at the point of its creation is free. This is its great strength. But whether from humility, error, madness, an imaginary desire for mortification, or simple aberration, artists and writers are often to be heard explaining how deeply the artist in capitalist society is deprived of his creative freedom.

Art only loses its freedom at the point of destination. It is true that the artist often believes he is imposing what in actual fact society, by its very speculation, implicitly demands of him. It is also true that the artist works neither for whom he pleases nor for where he pleases. So it is true to say

that he is conditioned.

But at the point of creation he is free. No one can deny that. All around us art and anartism are flourishing with unprecedented fecundity and prodigality. You can make anything out of anything and get it exhibited. No one will raise the slightest objection. Society will put no obstacles in your way. It is prepared to accept everything. It digests everything. It showers praise upon everything. Potentially it will even buy everything.

In most socialist countries, as everyone knows, liberty of creation can only be exercised within certain circumscribed limits laid down by official taste. Recently, at a time when it seemed in Europe as if abstract art had destroyed all semblance of reality for centuries to come, if not forever, abstract art constituted the political and intellectual avantgarde in societies where liberty of creation did not exist. In opposition to socialist realism and sugary narration, abstract art symbolised that liberty: the freedom to represent nothing at all. In opposition to limited means of expression, non-representation symbolised the artist's right to the pure and untrammelled play of colour.

Freedom for these artists was not abstract art as such, but the fact of creating the opposite of what was accepted, and consequently imposed, and thus of freeing themselves from restraints and prohibitions in the same way as the rest of the world was free.

And how many times have these artists been accused of capitulating to the decadent influence of Western art? Art can only be the servant of ideas as long as its service is voluntary, unsolicited,

26

spontaneous, and ineluctably pursuing its own inner course. The great artist serves only his convictions, whatever the work to which he may apply himself.

But here, when an artist thinks he is repudiating society, what he is repudiating is art—and himself. This is not Mayakovsky proclaiming in Moscow: 'The streets are our brushes. The squares are our palettes. . .' And Moscow, celebrating the first anniversary of the Revolution, was a mass of Futurist and Suprematist canvasses, Constructivist reliefs and sculptures the geometrical shapes of which pushed all the naive or declamatory allegories into the background . . . Lorries, trains, and the boats on the rivers all formed the object of suitable decorations, providing mobile support in the diffusion of art and ideology throughout the provinces. And as early as March 1918 Decree Number 1 published by the Futurists' paper and signed by Mayakovsky, Kamensky, and Burliuk proclaimed the need for a democratization of art and called upon the people to turn every street into a permanent exhibition of art and poetry. Next day Burliuk, perched on a fire ladder, hung his pictures from the roof of a house. The crowd applauded. . .'*

The entire avant-garde rallied to the Revolution, bringing its new art with it. And every avant-garde has, in the violence of its enthusiasm, proclaimed the death of art—but in favour of another art. There remains what Kandinsky called 'the essential: the goal of art.' 'We are . . . primitives of a new and

*From R.J. Moulin's very interesting study, 'A la recherche d'un nouvel art soviétique', in Louis Réau, L'Art Russe, Marabout Université.

27

hundred times greater sensibility,' announced the manifesto of the Futurist painters on 5 February 1910.

But here, in the West, to punish the bourgeois for buying art and the dealers for pushing it, the 'revolutionary' young anartist brings his anartism to the selfsame galleries, or waves his absence like a flag.

Why this persistence in dressing up gestures of whatever kind they may be in uniforms not designed for them? Neither the harvest of inventions and ideas nor the holocaust of fences and frontiers has ever before reached the proportions both assume today. The spectrum of creation is infinite, its springs running over in mad profusion. Art and anartism alike stand to gain.

They are not the cause of decadence; their falsification is. It is not art that is decadent in bourgeois society. Never has it been more brilliant. What is decadent is the way it is used, is fashion, is the fear of failing to keep up with the pack of avant-gardes upheld and labelled as such. Fabricated geniuses are foisted upon us from present and past, their names being taken up immediately by the chorus. The press is always a bit guarded about certain painters, not wishing to treat them too disparagingly but also careful not to praise them too highly. Others are greeted with a unanimous and extended shout of ecstacy. Words are inadequate. No scale is sufficient to place them high enough. Not only present-day painters are involved but painters from the past as well, the latter being necessary to provide forbears for the current vogue.

One man of rare character, for example, is by an astonishing piece of artistic hocus-pocus in the

28

process of being turned into a giant of modern art. That man is Duchamp.

The case of Duchamp is an extraordinary one. He has been chosen as the father of anartism, or rather, in the minds of those who have chosen him, as the father of the 'avant-garde' which has stepped into the place vacated by the death of painting. Marcel Duchamp's anti-art halo has been waxing for some while and has now assumed formidable proportions. It is among the more peculiar phenomena of our time.

This is because Marcel Duchamp, a great campaigner, carried his gesture of negation through to its conclusion. And he did it years ago. He exhibited signed objects. He became famous for his 'soupspoon safety catch' and for his 'ready-mades'. He was Dada.

Certainly he was against art and aestheticism, against received ideas, against primary representation, against phoney modernism, against the artistic establishment.

So he did the only consistent thing—he quit the field of art. He didn't go on playing around with objects or non-objects ad infinitum. He preferred to play chess. He translated his refusal into practical terms. He absented himself effectively. He turned his back on art. Attitude of mind. Refusal. What you will. But in any case logical. Consistent. Total. Or nearly so: he did still cast the occasional bronze 'refusal to create'. But then why shouldn't he? It was his right. Refusal is a mockery from start

to finish. And that includes selling it.

But there has never been a great creator, never been a great master who has thought in terms of refusal, of nay-saying. Duchamp symbolized forcefully a particular mental stance towards art at a particular time. But such a stance can also imply a certain impotence. It can never at any rate imply fertility.

And they are trying to turn this intelligent manipulator of ideas into a giant of modern thought, a champion of anti-art. They want to transform this Dadaist into a creative genius. This man who employed objects as they are in order to satisfy his genuine need for ridicule they want to claim as the father of a bunch of 'objectors' who take everything seriously. This debunker of the bourgeois they want to hold up as a torch of the new artistic establishment.

There is something almost pathetic in the sight of these dynamic young creators of anti-art flocking to the banner of an old soldier of art's forgotten wars. The difference is that he was a true rebel: he never wanted to re-enlist.

He conceived this actual stance of being elsewhere, and he adopted it. He smashed the idols, painted a moustache on the *Mona Lisa*, and quit the scene. But the scene is not a place the majority of our young—and old—anartists are particularly keen to quit.

Moreover refusal is something not everyone

is able to carry off. Indeed it is a curious thing to observe how the most burlesque manifestations of anartism tend to veer towards an aestheticism from which they never recover.

For example, the first time I went to a Fontana exhibition I was told: 'He's the man who slashes his canvases.'

Why not? It's a gesture. Except that slashing canvases is a one-time thing. Murder one canvas and you murder them all. Afterwards you run the risk of falling into a 'canvas-slashing period'..'.

That is exactly what happened to Fontana. He exhibited painted, slashed canvases. There was even an additional refinement: behind the hole he placed a piece of coloured material. Black. Or pink. It was a very aesthetic exhibition. Very restrained. Very quiet, in fact.

Here is what Francois Pluchart had to say about it in *Combat*: 'By piercing the canvas with a point or slashing it with a knife-blade he manages to convey in the most urgent and total manner a kind of confessional quality. . . . Emotion over against the world is captured for all time in the very moment of its formulation, without impediment or restraint of any kind. Once glimpsed, the canvas can be completed with lightning speed. It is the most complete expression of the cry . . .'

The title of the article was 'Lyricism carried to the power of the cry.' However, 'a technique as daring as Fontana's could quickly degenerate into academicism. It is in the nature of the creative artist never to allow himself to be caught in a trap, neither the trap of his period, nor the trap of facility,

31

nor the trap of success. Fontana avoids this danger by continually questioning and revising his techniques. . . Hence we find him changing the shape of his pictures, perforating the canvas from the front or from behind, before or after applying the paint, contenting himself with an incision or on the contrary falling upon it and ripping the wound open . . .'

Arman's raw material is objects. Sometimes he exhibits them just as they are. We have had domestic irons, for example, and a batch of aluminium kettles piled up several tiers high (*Salon de Mai*); we have had an agglomeration of electric-light bulbs (*Musée de l'Art Moderne*), and so on. People talk about Arman's 'rages', Arman's 'combustions', Arman's 'accumulations'. It is a fact that in 1960 he filled Iris Clert's gallery with actual rubbish. Restany has referred to this as 'the advent of a modern language of quantity—*accumulation*.'

Moreover, 'The dustbins of 1959-1960 are a concrete affirmation of the appropriative will . . .' (February 1967). And further, 'I am content to say once more that, with Arman, Cartesianism as a whole has invaded the realm of artistic perception. His work is the fruit of Cartesian method: the quantitative transcendence of the object as commonplace . . .'

I saw the works Arman exhibited at the Venice *Biennale*, where he was one of the artists representing France. His whole entry was delightful. The

collection of musical instruments artistically burnt and cast in polyester was characterised by the most refined aestheticism. Sometimes they resembled Cubist paintings, but in three dimensions, having lost their movement. The colours were soft, delicate, and pretty, the shapes graceful. All was harmony. Arman's work has tremendous charm. His taste is excellent.

For Otto Hahn, however, it is 'the pang of invasion', destruction as 'a final domination of the object'. 'The industrial world, considered as a human secretion, is the only one Arman is interested in . . .' etc. Furthermore (Restany), 'The value of Arman's work lies in its style: it commands respect as a parameter of taste, a catalyst of the forces of sensitivity . . .'

Arman himself is the epitome of these purveyors of disturbing ideas, these youthful and ebullient aesthetes, so extraordinarily satisfied with themselves, who carry their vilification of the customary as far as the television studio. The big boss of the *Ecole de Nice*, 'looking at the world through fresh eyes', once appeared on telly directing the incineration of a piano.

Yet he is a recipient of the Marzotto Prize, says his catalogue, and 'works of his are to be found in the following museums and public collections: the museums of modern art or fine arts or other collections in Paris, Stockholm, Amsterdam, Krefeld, Rome, Buffalo, Cleveland, New York, Brussels, Ghent, Copenhagen,' etc. I say this with no hint of mockery—discretion forbid. Consumer society or no, artists have always liked to see

museums buy their work, even when, like the French museums, they have no money to pay for it. Never mind. The work is on show, and above all in public. It is inviolable. There it will stay, and there it can be visited. The artist knows where it is and can from time to time, or one day—if he wants to, that is—go and take a look at it with eyes that have learned the lesson of distance.

All I mean to say is that a good half of our daring avant-garde is operating in a climate of success. There is an Arman exhibition on as I write. The title: 'Domestic Utensils'. The works on show are 'accumulations'. Thirty or so palettes neatly arranged to form a rectangle. Sticks of charcoal carefully lined up in rows. Tubes of paint in meticulously casual arrangements—the 'scattered' look. All are set in pieces of polyester. Highly decorative. The ideal window display for a paint shop. Brimming with ideas and good taste.

But then the raving starts. Christen the things 'accumulations' and you've done the trick. Arman himself appears to have no illusions about the harmonious, distinguished aspect of his work. But even he talks like a magus. The degree of earnestness and self-love evinced by our anartists is truly astonishing. Anartists are satisfied artists. This seems clear. What particularly distinguishes them is their innocence of doubt.

Painters as a body are admittedly not conspicuous for modesty. But the self-assurance of anartism is out of any kind of proportion. Raphael Sorin published an interview with Arman in *La Quinzaine Littéraire* under the title 'Arman: "I am a witness"

34

Sorin: 'You spend a part of the year in New York. It's a city you might have invented.

Arman: 'New York certainly is a gigantic accumulation. And in fact I did publicly sign the city in the bottom right-hand corner, the Lower East Side, in 1960, thus taking possession of this accumulation of people, buildings, cars, objects . . .'

'Publicly . . .' Always publicly. But at the same time it's amusing. And I can never walk past the household counter of a department store without seeing Armans all over the place. It just goes to show, What does it go to show, though? That it is a good idea? No one has ever suggested it is not. Ideas are in. This is the place for them. But art is the domain neither of ideas nor of good taste. Nor of the spectacular. Art is something else.

One of the most curious of aesthetes, stager of anartist spectacles, the darling of the frenzied sects of anartism and of all the gangs formed to put painting to death, was Yves Klein His canonization is in full swing.

They want to turn this man who died in the prime of life into some kind of archangel of anartism, a precursor, a god. They had been shouting from the rooftops how scandalous it was that there had not yet been a Klein retrospective. Finally one was put on in the Louvre, or rather in the *Pavillon de Marsan*. Klein himself would I am sure have preferred the Panthéon.

He was a character. Extreme in everything.

35

Extremely right-wing, extremely inventive, bursting with ideas and crazy mysticism, wanting everything, always ready with a phrase, fertile in invention and in the carrying out of his ideas, full of that special kind of poetic humour that made Yves Klein a somebody. He died in 1962, at the age of thirty-two.

I quote from his biography in the catalogue: 'His career was brief but brilliant. In fifteen years he went round the world twice, had some thirty exhibitions, spoke at the Sorbonne (1959), constructed a theory of the architecture of the air and made the first tests and experimental models (1958), completed the monumental decoration of the new opera house at Gelsenkirchen in the Ruhr (1957-9), made several films, wrote hundreds of working notes, and published a theoretical essay on 'Transcending the Problematics of Art' (1959). He founded the movements 'Monochrome', 'The Immaterial', and, in collaboration with Pierre Restany, 'The New Realism in Contemporary Art'.

Yves Klein was full of fads, full of ideas, and he had an undeniable gift for making others share his fads, for staging spectacles, for playing with the world and its sheep-like proclivities. It is a great shame that our wise men bearing meanings, our swashbucklers of art, our celebrants armed with the catechism of modernity and the breviary of the avant-garde should be trying to turn Yves Klein into something else. And murdering him in the process.

Instead of this exhibition someone should have produced a really good book about Yves Klein, about his soaring flights of fancy, his mysticism, his finds, his mad writings, his fantastic life. About

36

his gift for persuasion, about how contagious his fantasies were, about his faith in himself, and about the imperturbable seriousness with which certain people fell in with him and tried to make this brilliant buffoon into some kind of Galileo.

The man who said so endearingly: 'The artist must be capable of levitating,' and hurled himself from the first floor of a house . . . The man who (for a handful of gold) managed to sell some enthusiasts a piece of space, of nothing, the site of a non-existent work—a marvellous story. The man who amid tremendous publicity organized the opening of an exhibition consisting of nothing but the white-painted walls of the gallery and a detachment of the Republican Guard outside—an opening to which they flocked in their thousands. The man who, scorning brushes, used women instead whom he soaked in blue paint and persuaded to roll on the canvas. The man who said so many delightful and lucid things mixed up with verbal fits of a kind that even Restany himself could not follow, yet who also said: '. . .My work is not a search; it is my slipstream.' This man who was so totally permeated with self-infatuation—one of the characteristics of the *Ecole de Nice*—yet who went all the way: '. . .And so one very quickly arrives at the theatre without actors, without scenery, without a stage, without an audience. . . with nothing but the creator alone, seen by no one. . . and the theatre of a spectacle is born! The author lives his creation; he is his own public, his own triumph, his own flop. Soon even the author is no longer there, and yet it all goes on. . .' The man whose very death was at first

37

received as some fresh stunt. This man, whose madness was in earnest and whose fantasy knew no bounds, has been utterly betrayed by his friends. They have promoted him to the Establishment.

What is more, even they were embarrassed by the solemn, strained, funereal atmosphere which reigned in the *Pavillon de Marsan*. All was laid bare. It was the moment of truth.

The fact is that there is not and never has been an Yves Klein *oeuvre. Not without him there.* He never made works; he made gestures. Take away the author in the process of making them and there is nothing left. Less than nothing, even. (This observation has been made before in connection with other exhibitions. So that the exhibition that had been so highly publicized as the most advanced manifestation of the avant-garde, our abasement before his absence, turned out to be a posh, quiet, empty affair, a vacuum in blue and gold. Without the naked women actually rolling on them, the blue-smudged canvases were less than mediocre-figurative. The monochrome paintings were just monochromatic. Lined up along the wall, blue upon blue upon blue, they were simply blue. Nothing more.

Restany's preface to *Propositions monochromes d'Yves Klein,* entitled, as it happens, 'The Moment of Truth', begins: 'To all addicts of the machine and the big city, to all those who are gone on rhythm, to all masturbators of reality, Yves offers a rewarding and enriching cure of asthenic silence. Far beyond the unfurling of other worlds, already so far beyond the reach of our reasonable common sense. . .' and so on and so forth.

38

'Yves Klein, precursor of the new humanism . . .'

'The returning Gargarin proved him right: seen from outer space, the earth is blue . . .'

His playing with fire produced lean and graceful results. Yves Klein wrote: ' . . . And in the same period I succeeded in painting with fire, using for the purpose especially powerful and dessicative gas flames, some of which approached three or four metres in height. I made them lick the surface of the painting in such a way as to make the painting record the spontaneous mark of the flame . . .'

Flies' feet or dogs' pawmarks, fairly regular and flame-coloured.

Dr. Paul Wember, curator of the Krefeld museum, writes as follows: ' . . . For him "emptiness" has become the goal to be attained. Man must enter into possession of his inner life and also of this emptiness whose symbol is spiritual plenitude. On the basis of this conception of his monochrome paintings as realised emptiness he has arrived at the immaterial picture and even at an immaterial exhibition. Thus in January 1961, at the Krefeld exhibition, he created an empty room in white which is probably the only one of Yves' immaterial rooms still in existence . . .'

Lucky Krefeld museum! At the *Pavillon de Marsan* we got more for our money. Lots of gold. And those pretty pink and blue sponges stuck on rods like hats. The whole thing being like some luxury show-room out of another age.

That is what they have brought him to, this great inventor who played such pretty games, this stager of spectacles, this madness channelled into the

avenues of publicity, this creator of walls of water and fire who once said: 'I am deeply convinced that there is latent in the very essence of bad taste a force capable of creating things that far transcend what is traditionally known as the "work of art". I am very, very excited about bad taste at the moment . . .' This enemy of good taste as the enemy of art has been immured by his friends in a mausoleum of good taste. This mighty little master of nix, this dandy of nothingness, this aesthete who always made me wonder what he himself thought about the extraordinary success that greeted all his tricks—they are trying to turn him into a giant of modern art. A Christ of the controverts. An exemplary creative artist.

It's tough on him, but his admirers are determined to do it. What is more, they are setting about it with pitiless militantism, writing, lecturing, broadcasting, staging spectacles . . . The thing is snowballing. It is fascinating to watch. We are well on the way towards an academicism of emptiness which promises to be the most typical of all our society's academicisms. And without Yves Klein. Without the least spark of humour.

Finally, a couple of extracts from Restany's article in *La Quinzaine littéraire*: ' . . .Yves Klein, who lived out in his work the progressive revelation of planetary consciousness: the fixing of free energies through paint, the identification of paint with the space thus rendered dynamic, the dematerialisation of the coloured pigment and the perception of space as "filled-empty", and, concluding this flight of intuition, the restitution of a

universal synthesis on the basis of the elementary principles of energy, blue, gold, and pink reunited in flame, in fire . . .'

The article ends: ' . . .Time is more than ever on the side of Yves Klein, prophet and martyr of our Mutation.'

I have dwelt at some length on Yves Klein because his spectacles were among the finest anartist spectacles there have been. Not forgetting the bystanders, of course, who were a part of them.

Spectacle, the theatrical aspect—which of course includes by definition the publicity aspect—is extremely important to the anartist. And the most extraordinary of all such spectacles are Tinguély's.

I remember when in the heyday of abstraction one of Tinguély's machines stood on the esplanade of the *Musée d'Art Moderne*, whirling away with a lot of noisy explosions and spewing out sheets of paper. People ran to pick them up and discovered that Tinguély's machine was manufacturing . . . abstraction.

As a rule, though, they do not manufacture anything. They just operate. They are big, intricate things, an inextricable jumble of moving parts, a shapeless shape. Occasionally, like everything else, they get exhibited, forming the centre of attention at anartist spectacles in museum courtyards before delighted crowds. And when the show is over they explode and there is nothing left. Or hardly anything.

They're marvellous. Tinguély's machines are witty, wise, insane, and ingenious. Not that they are machines really. They are just pointless mechanical to-ing and fro-ing. I love their absurd complexity, their suggestion of Gulliver's voyage to Laputa. If Tinguély had visited Laputa he would have joined forces with the men who built their houses starting with the roof. Tinguély's machines are fine, unadulterated anartism.

Philippe Comte writes in *Opus* magazine that the machines 'no longer paint, and they no longer explode. In their increasing but controlled insanity they possess a guaranteed absurdity, and this very absurdity calls into question our smug security, our chronic need for reassurance . . .'

Tinguély would like to build a 'Lunatrack'. I quote Christine Duparc in *Le Nouvel Observateur:* 'A building measuring twenty-eight metres in width and one hundred metres in height, clad entirely in glass like a Mies van der Rohe skyscraper. Cost: one thousand million *anciens francs*. At the bottom, a garage; at the very top, a restaurant (with spotlights sweeping the city). In between, the fair: slides, shooting galleries, ghost trains, roundabouts, Ferris wheels, fountains, bumper-cars, parachutes, snack-bars—a vertical, concentrated version of the old Luna Park fitted out with all the gadgets of the technological age. The clever thing is the façades . . . a surface area of twenty thousand square metres will be animated by a constant barrage of bright lights . . .'

What are they waiting for? It would be marvellous.

Claes Oldenburg wants to make a hundred-metre-high potato. Great. All for it. There ought to be places set aside for this sort of thing. And for all the many other marvels of anartism. I am quite serious. For Pino Pascali's (the tin-channel man) *Whale Going Through A Wall*, or his huge plastic-brush silkworms, or his twenty-five-metre dinosaurs with their canvas and wooden vertebrae. For Niki de Saint-Phalle's 'nanas' too, and her enormous reclining nude, between whose legs apparently more than a hundred thousand people filed in Sweden, because you could walk around inside. What could be nicer? No one objects, do they? Niki de Saint-Phalle is the carnival of our time—no kings, no queens, just ordinary men and women.

If there were exhibitions like that, with special sites set aside for them; if they were taken abroad on tours simply for what they are, no less and no more; if no one insisted on mixing it all up with painting and sculpture and trying to pretend it lies in direct line of succession to Rembrandt; if the *Biennales* and other occasions—always spurious in any case—were not stuffed full of it; if painters and sculptors received as much attention as anartists do, and were moreover treated as being in a separate category, then no one would have any objection whatever. Except, of course, the critics in question.

And there could be special rooms in which certain anartists could be shut in with their mysteries. The amazing, marvellous Kudo, for example, bathed in black light at the height of a happening, with his sharp colours, his no-bird cages, all those death-ideas imprisoned behind bars or on sofas. This kind of

43

composition often requires the presence of the artist in person—or of someone, at least—perhaps, as at the *Salon de Mai*, holding up the parasol of colour unfurled in the almost spectral atmosphere of an atomised world.

César would be there too, producing—in public, as usual—his plastic 'expansions' in the form of gigantic eiderdown-hams, like the one he did at the Tate Gallery, for example, where the crowd greedily shared the pieces. Or the pieces could afterwards be exhibited. Or a museum might go so far as to purchase a whole one. During the portion of his time that he spends as a sculptor, César would exhibit over the road.

And there would be starker scenes. Larry Bell's boxes, for example. There was a curious exhibition at the Sonnabend Gallery. At first glance one saw nothing but a lot of socles, and one's immediate thought was that one had come on the wrong day, or too early, or that they had simply forgotten to put the sculptures up.

A second glance revealed that the socles were made of mirrors and panes of glass, of shiny, sophisticated materials.

Then, thirdly and lastly, one looked at the socles themselves. But even with all the brilliant reflections, they were still just socles.

The following is taken from Annette Michelson's introduction to the catalogue (New York, May 1967): 'Pure intellect and pure material constitute the bounds of Bell's domain . . . The subsequent elimination of these forms, the perfection of a range of techniques of reflection and transmission,

of echoing colours, have simultaneously eliminated from the surfaces that quality of elementary aestheticism and contributed towards dominating the spectator's sense of self and of his environment: the spectator henceforth apprehends a spatial continuum, stretched or concentrated, modified or arrested, created or everlastingly denied by the reflecting surface. The peculiar merit of Bell's reflective or rather reflexive art is to stimulate in each one of us—in a way which is both tender and disturbing—an awareness of our own perceptions ...'

I am simply amassing various observations, this time to bring me nearer the centre of my environment. Here are some which may šerve.

Firstly, in what does the shock-power of objects reside?

If you exhibit an ironing-board in a kitchen, or a hundred-metre-high potato in Luna Park, or a neon sign in the sky above Broadway, or a socle among other socles, or a giant flower-pot in a garden (like those huge and magnificent jars which stand amid the greenery and the steles of the Thermae of Diocletian in Rome), everything remains quite normal and dormant. So what must count is the fact of removing the object and placing it on its own somewhere else.

It is an interesting idea. You make something of a thing by taking it out of its context. You see it with new eyes.

But that is not enough. If the place you put it in is a place devoted to art, the critics will then be able to invest the thing with the power to administer a mental shock. And the artist becomes a genius at

45

little intellectual cost to himself.

Secondly anartism can also play into the hands of every kind of incompetence. If, in the atmosphere created by the best anti-art criticism, I exhibit an egg at the Louvre on a suitable socle and in the requisite verbal climate, not only do I subsequently stand a chance of getting exhibitions everywhere but I may also become the celebrated creator of a giant egg. But the enlargements are done by firms with special equipment and experienced technicians. The creators only make the rough models. And no-one would dream of holding this against them.

So the abode of anartism is of prime importance. Because if there is able anartism, there is also incompetent anartism.

Thirdly, there can be no anartism in the absence of frenzied enthusiasm. Either you are in it, or for it, or you are nothing. You are not allowed to like it as a new and valuable form of the kind of freedom that lies at the root of every constructive achievement. Your feeling for it must be exclusive. You must put it in art's place, and hence not just anywhere.

The galleries are already in their hands. The occupation of the museums has begun. At international exhibitions they are present in their hordes. They want the lot. Painting is spat upon and what is more, it is driven out. But when a museum exhibits or buys a piece of anartism it comes in for the most extravagant praise, being hailed as the museum of the avant-garde, curator of the power to shock. The avant-garde clasps it to its bosom and

showers it with fulsome eulogies. Oodles of publicity and oodles of ballyhoo.

Challenge? Controversy? Revolt? Refusal? Not a whiff of one nor t'other in the majority of cases. It is highly debatable what in fact we *are* dealing with. It could be diversion, derision, decadence, or organised insanity—probably all of them together—certainly speculation—and at the same time one great and glorious game of grab.

Does it never occur to our young anartists to wonder how such violent verbal revolutions, such lofty refusals, such magnificent flights of scorn have for a long time been so widely accepted and indeed so much in demand that the entire world is inundated with them? The dealers, galleries, and museums are the same for all. What difference is there between so-called dead or academic art and this bourgeois anartism?

They even have their didactic exhibitions, their explanatory lectures.

One day a catalogue arrived at my place containing five paintings in reproduction. Five reproductions, I should say, of five absolutely identical paintings. Nothing difficult: a little black circle in the middle of a big white square.

The author of the paintings, Olivier Mosset—whom I hope the impassioned support of the anartist critics will not succeed in committing to this circle for ever—writes in the catalogue: 'I am not having an exhibition (though if someone were

to offer me one I might accept) but it occurred to me that it would be just as interesting to publish a catalogue without an exhibition . . . I should like to be able to live by this kind of painting. It would make no difference to the painting, of course, but it would change my relationship to it . . .'

One hopes so, for his sake.

It is true that for young painters the atmosphere is far from congenial. It is also true that a good many of them give up, mount the stage with their non-painting, and one day find they have become celebrities.

Alain Jouffroy has written in *Opus* magazine: 'The most important recent exhibition of painting in Paris lies between the covers of the catalogue of which I speak.

' . . .One thing, at any rate, is clear: not for a long time has a young painter hurled down such a challenge as this. I should like to say more, but if you can understand that exhibitions in galleries no longer interest me overmuch, if you just accept once and for all that the abolition of art is not just a manner of speaking but a theory which involves its own putting into practice, then you will appreciate the importance of this gamble called "Olivier Mosset".'

Mosset's name cropped up again when he, Buren, Parmentier, and Toroni decided always to paint the same picture.

Buren, though, began to make a name for himself

with his awning canvas. I remember one *Salon de Mai* when he had a sandwich-man parade up and down the street with some of it on his board. These are his materials—canvas and striped paper. Apparently a collector has asked him to decorate an entire room. So that, having 'emerged' from awning canvas and wallpaper, he would seem to be going back to them.

But they were a group: Mosset doing his circles, Buren his vertical stripes, Parmentier his horizontal stripes, and Toroni his coloured dots. Before the group broke up it put on several shows. At the *Pavillon de Marsan,* where they did nothing, at the *Salon de la Jeune Peinture,* where they did their stripes and circles and squares in public, and at the Paris *Biennale.*

And by Grégoire Muller, in *Robho,* we were told: '. . . One senses an evolution in their attitude through these three manifestations: from the pure negation of the beginning they moved on to a kind of visual invitation, finally holding all other painting up to ridicule.

'The most complete negation would have been not to paint at all (as some have advised them to do!), but such an attitude would have been incommunicable; continuing to paint, they have transcended pure negation and pure frustration and have charged their paintings with all the force of this attitude in order to render it accessible to others. The art of painting has led them to surpass in complexity the logic of their first manifesto: a negation of any kind of "message", the painting yet re-becomes message, namely the message of that

negation; and that negation exists only in relation to the affirmation of its existence. . .'

It is this 'affirmation of existence' which is the essential point. 'Their whole effort has consisted in reducing the qualifiers as far as possible to nothing in order to show only this raw existence. In Buren's case it is neutrality of form. His stripes are of middling width. Any wider and they would express gravity; any narrower and they would express serial rhythm. . . Mosset's circle, on the other hand, has potentially so many contradictory meanings (nought, the symbol of wholeness, the letter O, a target. . .) that they cancel one another out. Parmentier's stripes, painted (rather indifferently) with a spray, achieve by their deliberate silliness an effect of total nonsense. Toroni's surfaces with their spots of "joyful" blue give a strong impression of uselessness, of gratuitousness, and constitute a final mockery of any kind of "message". . . '

We are already, you see, a long way from the object. The object is far behind, fading into the distance. We see things in broader terms now.

The most characteristic example of this development is Sanejouand. I have seen some of his works. Actually 'works' is not quite the word for them. I find it difficult to define some of the things I saw. A kind of geometrical abstraction in three dimensions. A series of connected squares, for example, in line abreast along a wall at floor level,

like huge ravioli before they have been separated. Yet much more than that, as we shall see.

Here are some extracts from an article by Christiane Duparc in *Le Nouvel Observateur:* 'But where on earth are the works? ask all the poor fools who've been had, who have got out of touch, whom the new has left behind, as they point a furious finger at the bare wall of the Yvon Lambert Gallery where the subtle Sanejouand is currently having an exhibition. . .'

Unfortunately Sanejouand, though clearly on the right road, still has a remnant of art in his bones. 'There remains one ambiguity: the author of these works has not yet managed completely to neutralize his organising objects. His containers are picturesque. . .'

Poor old Sanejouand.

'. . .His pieces of crane are like sculptures. . .'

Bad. Very bad.

'. . .His attempt is interesting in so far as it is in line with the dominant trend in contemporary art, namely the calling into question of the object. . . By robbing the object of all importance he is in a highly personal fashion working alongside the artists who have undertaken the task of atomising sculpture and making it explode in the environment. . .'

'. . .Art is no longer in objects. It is in the space which objects make us see—and experience.'

What is the avant-garde, then? It is the newest find, the latest fashion. At the time of my writing

it is disappearance in the environment. A short while ago it was objects. It is always, in any case, that which is not art.

There is no risk involved, of course. In fact it has become almost absurdly easy to be avant-garde. Everyone knows exactly how to go about it.

The funniest thing is the way the bourgeoisie is advised to purchase the results. The dreariest thing is the way the avant-garde snatches at the first opportunity to seize power and enthrone itself in the academic chair of the avant-garde-elect.

Yves Carre did a feature on Pierre Cardin for the male fashion page of *Combat* one day under the title: 'Men: new market for manufacturers, aesthetes, and creative artists'. Here is what he wrote: 'For his Place Beauvau *cité* Pierre Cardin has designed the model town house for the man of sophistication who is at the same time an enthusiastic admirer of all that is most up-to-date in the world of art. For example he deliberately refuses to hang on the walls of his *salons* any works by artists whose creation belongs as of now to the past.'

Notice the way that last bit is put.

'Instead he has chosen only up-and-coming painters, painters who—without a doubt—include the new masters of our school.'

Ditto.

'Aware on the one hand of the social promotion he is offering creative artists and on the other hand of the responsibility this throws on him, Pierre Cardin has chosen those young talents of contemporary painting whose originality is sufficiently

marked for experts to be able judge here and now the innovatory character of their work. . .'

I suppose no one will have failed to recognize in this quite extraordinary sentence the specialized language of the art critic.

Art criticism, by the way, has come up in the world. It now plays, among creators suffering from a shortage of ideas, a creative role. It points. It chooses. It labels. And then it pushes.

The fact is that, since Cézanne and van Gogh, the experts have always been right. Obviously, for they are in the know. They're even more in the know than the creative artist himself. They hold court, they have their cliques, their coteries, their coalitions, and their *pensoirs* at which, among other critics and anartists of like infallibility, they look down upon the old world of the arts from the lofty heights of their common genius.

At the *Concours Lépine* of anartism, the critics, with an eye to the most successful international trends, select the genre-to-be, the dazzling discovery, the brand-new bombshell. *Eureka!* they shout, and proceed with extravagant praise to proclaim the brilliance of their new find.

In the catalogue of the Fifth Paris *Biennale*, Gérald Gassiot-Talabot calls for 'an annual review of the avant-garde'.

In the same catalogue Palma Bucarelli writes: 'There is among the young neither a spirit of conformism nor a spirit of polemic, nor is there any

sign of the crisis that tormented the preceding generation. So that the term "avant-garde" no longer makes any sense. It would mean the beginning of a new tradition, and no young artist, of whatever school, seriously thinks in terms of founding a new culture. . .'

It is amusing to think of van Gogh or Picasso worrying all the time about being with it, about whether they were innovating, about whether they were still up-to-date. It is the mediocre who 'look modern' and spend all their time making innovations. True creators do not think in terms of found- a new culture. But they are obviously a quite different kind of avant-garde, the kind that is looking for a truth about the world, not for success. This kind of avant-garde is never born in a climate of success. Must the time come, then, when we look back with nostalgia to the day deputies took the floor in the Palais Bourbon to demand the expulsion of foreign painters accused of Cubism?

But anartism and its merry-go-round of ideas are not confined to the marvellous or ludicrous purlieus of which I have been speaking, with their mixture of imagination, madness, thought, and cunning, the desire to seem everything and the taste for having everything, fantasy of the most inventive and success-seeking of the most facile kind, money, publicity, and poverty of ideas, criticism more arrogant, more cock-sure, and more daft than it has ever been, and a younger genera-

tion more irreverent and more greedy to make a name than any the world has ever seen.

There is another kind of anartism which is thoroughly rational and deeply thought-out. Outside the realms of painting and sculpture certain techniques have emerged in recent years in a way which is extremely promising. What is known as kinetic art has begun to make its presence felt both in the commercial world and in the world of ideas. Squares, circles, lozenges, Vasarély's optical effects, Schöffer's works with their play of light and metal, the illuminations and metallic movements of Soto, Le Parc, etc., are becoming increasingly accepted, meeting with ever greater success, and gaining more and more adherents.

These are no recent discoveries. These techniques were invented ages ago. Artists have been experimenting with simple geometrical shapes and with the movements of metal and electricity for years. But it is only comparatively recently that people have begun to take a real interest in the work of men using these techniques.

Today their success is evident all around us. In the fields of interior and exterior decoration, in the optical animation of architecture, and in every context of movement treated as spectacle and neon treated as material for ideas, they have come to occupy an important place in society.

The way the arts of decoration and illumination have proliferated is or can be extremely exciting. Christmas 1968 Soto decorated the Place Fürstenberg. Nearly everyone was against it. But the reason was that the Place Furstenberg with its marvellous

old lampposts was simply the wrong choice. Soto ought to have been given a new site, not this perfect example of an ancient square that can stand by itself and needs nothing else. There is no shortage of sites in Paris suitable for architectures of metal and light. If Schöffer erects an enormous luminous tower on top of Notre-Dame, everyone takes part in the protest demonstration. But if he does it on the Rond-Point de la Défense everyone signs the petition in favour.

Moreover, everyone *is* in favour of this kind of thing decoration, architecture, colour, animation. They have no enemies. They go from success to success. All doors are open to them—official circles, financial and industrial circles, lecture rooms, exhibition rooms, radio, the stage, television, etc.

All this is quite normal and desirable. Modern science and architecture need adventurous minds to overthrow the old traditions of ornamental lighting and mural decoration. Environment! More, more! Science provides the impulse, architecture the opportunity, and space the occasion; experts in kinetic art, optical and electrical effects, animation in metal and neon, drawing their inspiration from science, in turn enrich it. Colour schemes are no longer determined by a decorator's good taste but by the rational and scientific manipulation of relationships. The stage, swept clean of the old 'modern' art of cheap-jack gimmicks and papier mâché vegetation, now blazes with gorgeous colours harmoniously distributed in squares and circles. Our television programmes are alive with it. Movement, light, neon—it is everywhere.

There are two disadvantages: one small—and negligible; the other more substantial, and more serious.

The small one is the risk of monotony. Small because it is not hard to remove. Squares are not the only things in the world. Our world is already too full of corners, and the unchecked spread of geometrical decoration may lead to endless repetitions of symmetrically alternating colours or cleverly arranged discs stretching as far as the eye can see.

The same goes for neon. There is nothing gay about neon art; the art of Schöffer, for example, is harmonious and strict; that of Le Parc, with its blind metallic movements, a thousand times more so. The kinetic art exhibition at the Paris *Musée d'Art Moderne* in 1967 was, amid the muffled sounds of metal in movement and the flashing lights, an earnest affair of pure decorative abstraction.

It is true that, since Leger, colour and form in window dressing have undergone a change, that the Delaunays started it all long before that, that the gigantic light-sky of Broadway does exist, and that the whole world has always been full of this kind of thing, from the revolving lights on top of ambulances and police cars and the snakes of light you see writhing about in chemists' windows to fairgrounds and cascades of light like the Renault window display on the Champs-Elysees some years ago.

But it would be a phoney argument to use Broadway or the marble squares of Rome as a stick to beat Schöffer or Vasarély with. Today it is they who place themselves at the service of the city, using and rationalising everything, searching, experimenting, seeking to bring back life to the forgotten places. They pursue with their geometry the city's habitual movements, but they transform them, and the city listens with surprisingly keen attention. They are everywhere to be seen, innovating, inventing.

Furthermore, if people will only go on supplying them with the means, they will change as they go along in accordance with the needs of the time, and maybe this fear of monotony will prove to be unfounded. That is not the danger. The danger lies in their own attitude and that of the people who back them. Because in consequence of goodness knows what mental aberration they have decided that painting and sculpture are dead. And that from now on painting—and sculpture—is them.

True, they are not the only ones. From Italy to the United States and from Paris to Quebec, kinetic and neon art are unanimously held to be the only kinds appropriate to modern society and adapted to the techniques it offers. Painting and sculpture are a thing of the past.

Here too the offensive is in militant hands. You simply cannot open a newspaper or switch on the radio or TV without seeing or hearing Vasarély or

Schöffer announcing that, although painting used to be painting, now it is what they are doing.

Instead of spreading themselves wherever they wish in their own fields, to which no one would have any objection, they spend their time ousting and supplanting painting and sculpture wherever these still continue to exist. They are giving themselves a great deal of trouble for nothing. Because their art is not the least little bit in dispute.

They have influential galleries. They have had a big exhibition of kinetic art at the *Musée d'Art Moderne*. Vasarély and others have had one in the *Pavillon de Marsan*. Schöffer is hard at work in his world of light. He won the Grand Prix at the Venice *Biennale* of Ex-Painting. The art windows of the big bookshops are almost exclusively devoted to them and to those who share their attitude towards creation. Television is wholly given over to them. So is the majority press. They have conquered the official world, the industrial world, and the world of architecture and urbanism. You can no longer travel anywhere without finding one or other of them lecturing at the local museum about the death of painting and the glory of what has taken its place.

They speak, they write, they broadcast, and the death knell of painting and sculpture echoes on every side. In the arts there is truly no new thing under the sun. The death of art has been announced innumerable times. But never with such force, such bitterness, such universal approval. And never in the name of arguments so contradictory.

Vasarély urges, 'Let us first extinguish in ourselves all trace of egocentricity. From now on only teams, groups, or whole disciplines can create; cooperation between scientists, engineers, technicians, architects, and plasticians will be the *sine qua non* of the work of art.'

Perfectly true. In this field of decoration, and decoration often on a gigantic scale, team-work is absolutely essential. Vasarély himself has a large team at work in his workshops. In every field of geometry, in every field where ideas and not thought are the guiding factor, team-work is today a necessity. The more so since, in Vasarély's field, although a project may be realized with a greater or lesser degree of success or brilliance, there can never be any such thing as a flop.

This is an essential point if we are not to confuse these two worlds. In this art of harmony, decoration, movement, and neon, everyone can follow suit. Everyone can imitate. Everyone can work in the same field in the same way. Better, even, than Vasarely, although he does still seem to be the best. People complain that he has too many imitators. It is only because the possibility is there.

But painting is not a technique adapted to an idea. It is a mind in search of an understanding of the world. It is not, like a technique, something that any interested technician can assimilate.

One of the gravest mistakes of our time is the attempt to extend the team-work principle to 'painter'-painters. And the mistake is underlined by the artists themselves who, as soon as they begin working communally, leave painting and turn their

attention to the environmental.

Vasarély has also claimed, '. . .The art-idea is quitting its age-old fogs to luxuriate in the sunshine of the vast network of modernity which is being woven around the globe. . .'

I don't know what Vasarély means by 'age-old fogs'. If the 'ages' in question are those of the history of art, the 'fogs' would seem on the contrary to have been pretty bright. . .

Yet another quotation: '. . .The pattern-pictures or "starting prototypes" which I created with the aid of a complete alphabet of plastic units comprise innumerable morphological virtualities translatable into black-and-white (positive-negative), black-and-colour, white-and-colour, and colour-and-colour using contrast or harmony. If you add the mirror-images, the many different directions, the different sizes, the chromatic combinations, the permutations of the various motifs, and the alternation of vibrant and silent surfaces, you will get some idea of the infinity of possibilities available. . .'

Certainly. In other words the materials must be invested 'at the start' with 'sensitive properties' and the 'aesthetic unity' of the construction will be achieved. And don't forget that the 'plastic unit' is the square. And that it can be changed through choice.

Nobody could object to that. Vasarély and his like have unlimited scope. There is no shortage of surfaces. They have everything they need for the

fulfilment of their mission of harmony.

But be careful. If their mission is decoration, animation, elegance, harmony—fine. If they can create a new domain holding such riches— marvellous. May they be the masters in their tailor-made world.

But if this is taken for painting and sculpture, it's the end.

Vasarély has gone so far as to state, in an interview with Polnaref on the stage of a variety theatre before the television cameras, that painting used to be this, that and the other, but that now it is what he and his colleagues are doing. The pretty girls paraded past in Vasarély fabrics. Well, why not?

Especially as the Delaunays did not stay around until 1969.

And the critics lend a hand in this insane attempt to dehumanise art. As a typical example I have chosen an article by Argan in the catalogue of the 1968 Venice *Biennale.* He will now seek to persuade us that the least little piece of geometry is pregnant with thought.

You entered an apparently empty room. It was the room devoted to Mario Nigro. Looking carefully, you discovered that hanging here and there on the walls were a number of little metal crosspieces, looking like something left behind in a

deserted hardware shop. Tiny little metal cross-pieces. Some a bit longer than others.

And if you had not read the catalogue that was all you would have made out.

But you did read it. And then you made the discovery that the article by Argan which you had just—not without difficulty—deciphered was in fact about these cross-pieces. You couldn't believe your eyes. But it was...

'The search which Nigro has been pursuing with the utmost rigorousness these last twenty years is an investigation. . .into the current significance of space and time. . . The goal is not to communicate something but to condition the spectator. Yet without invading him: the impact of perception having been avoided, there can be no emotive deflagration. Instead there is a gradual stimulation of emotivity in so far as this is inevitably realized in space and time: hence and space time do not appear as representations or concepts but as actual existential realities, as tangible dimensions of past, present, and future experience. Because, if this search is pursued in the realm of pure virtuality, there can be no question of space and time being determined; but when Nigro talks about "total" space and "total" time he is not referring to a metaphysical globality but to an unlimited expansion. . .'

So don't go thinking geometry is just geometry. It thinks. It even thinks complex thoughts. And

63

so, as modern art, it is a perfectly legitimate heir to all that has gone before.

The example I have just given was one typical little detail. The entire Biennale was a dull, disembodied world, dominated by the strictest geometry. Beside this dogmatic anartism, the more imaginative kinds of anartism provided the occasional light moment, or at least a note of gaiety. There were whole rooms full of discs, squares, cubes, signed wooden beams, little black squares and big white squares. Mile upon mile of stripes by the Canadian Guido Molinari—he has been doing this for a long time—and lovely big stripes they were too. Optical illusions, fairground vistas, back-to-front perspectives, mirrors, wires, masses of 'elements', and the greater part of the English pavilion taken up by kinetic art consisting of tiny discs and little geometrical jerks. You couldn't stay in there for more than two minutes without your eyes beginning to run; it was so tiring. Holland exhibited a zigzag, among other things. Iron girders lying on the floor in a zigzag. There were two pages in the catalogue devoted to the artist responsible, and they really opened my eyes to the extent of my inability to appreciate the spiritual content of the zigzag. And yet it was a very serious zigzag. It was just that I could not manage to see all that complex thought in it, nor how it might be possible to recognise in these severe and rigid works the sign of 'a typically Dutch form of Calvinism...'

However, there was also neon all over the place. Gadgets, kinetic art, and neon had the lion's share of a *Biennale* at which, apart from the Futurist

rooms—very interesting as providing a lesson in modernity—and apart from the Delvaux room, one or two attractive anartists here and there, and an ice-cream van (signed), the painting was poorly chosen, poorly presented, and deeply uncomfortable. In fact, it was cleverly tucked away.

Essentially the *Biennale* was theirs. Schöffer—who carried off the prize—exhibited a very fine, very beautiful invention of moving, coloured light.

In other words, at the most popular international exhibitions—up until 1968, at any rate—in museums, and at official artistic events, kinetic art and neon, along with the more imaginative kinds of anartism, are in the process of elbowing painting out. And no one—let's face it—is doing anything to stop them.

But what more do they want?

Fundamentally there is something almost moving about the frenetic enthusiasm with which these men of talent and occasionally of genius in their particular fields, not content with what they have, still, whether consciously or unconsciously, aspire to the title of 'thought'.

Schöffer is the most relentless and militant of them. According to him the death of painting goes back a long way. Schöffer has recently installed a 'cybernetic structure' at the Rennes *Maison de la Culture:* 'Contemporary painting and sculpture don't interest me. Can you imagine anyone nowadays building a factory for the construction of horse-drawn carriages? Of course not! Well, it's the

same with art: brushes were all right for painting and mallets for sculpture between the fourteenth and seventeenth centuries. . . (in *Ouest-France*, 25 January 1969).

But the main point of error is not in the assimilation of art and science in terms of the evolution of the one and the progress of the other. The most serious mistake—and it is dangerously widespread—is to be found where art meets society.

Because Schöffer and Vasarély, each in his particular field—and I must apologise for treating them as prototypes (if we were discussing painting it would not of course be possible to do so, but in this domain there can be and are men who typify what they do and what others do differently, or no differently, but at any rate in the same order of decoration)—Schöffer and Vasarély insist on brandishing these altruistic, social, almost bountiful notions of art (their art) in society. They want to spread it around.

I quote Schöffer, who was interviewed by André Parinaud in *la Galerie des Arts* under the following introductory note: 'Nicolas Schöffer and the "Programmed Environment" department at Philips have just presented the Lacloche Gallery with the Lumino, a creation of Nicolas Schöffer's; the internationally famous light-sculptor and cybernetician

has invented a machine which, in being commercialized, shows the importance which the new conceptions of art have assumed in our society.'

The Lumino is a small, portable Schöffer which can be moved about like a lamp and which you can have in your home.

Nicolas Schöffer says he wants to 'socialize the work of art'. Because 'bourgeois society has got hold of art and has alienated it both on the social level and on the creative level. Artistic production is in the service of speculators who have turned the work of art into a commercial article. The phenomenon has corrupted both artistic creation and the artists who are forced to compromise in coming to terms with the propertied classes and to turn out products capable of becoming objects of speculation, i.e. desocializing art. . .'

Schöffer is looking for what he calls 'solutions of socialization', which take the form either of distribution programmes for aesthetic products on an urban scale or of a small and not too expensive industrial product within the reach of every pocket.

What is more, he claims that this will make it possible 'to replace such long-obsolete and antediluvian techniques as easel-painting and pedestal-sculpture, which stand in the same relationship to art as the horse-drawn carriage to modern traffic. . .'

The nostalgia of the artist at the mercy of dealers and the market is legitimate. The

destination of art is hardly inspiring. But the way in which all that is being changed around amounts to one of the great howling deceptions of all time.

We will forego discussion of this social object, the Lumino—exhibited in the Place Vendôme in exactly the same way as horse-drawn painting is exhibited, and distributed by the firm of Philips—considered as an attack on the commercialization of art by bourgeois society. . .

I would rather quote some of the hypotheses advanced by Frank Popper*: '. . .Kinetic art will merge with architecture and become an art of the environment. . .'. '. . .Art will become an industrial product. . .mass-produced in unlimited numbers of copies. . .' Or, art 'will become pure research, like science. . .'

Why not? This is the accelerated but, as it were, normal progress of art. I mean of course kinetic art—a slight difference.

In this field the hypotheses are endless, stupendous, exhilarating beyond words. The following is taken from the editorial of the November-December 1967 issue of *Robho* on the subject of the unlimited possibilities that electronics has opened up for artists: 'Henceforth artists will be able to use, at the ORTF Research Centre, a tele-visual keyboard with which they can achieve instantly the kind of picture-mixing which film-makers used to have to spend hours in the laboratory to achieve. . . When

* In *Bulletin d'Information et d'Études critiques,* no.28, published by the *Biennale de Paris.*

68

one thinks that the artist has only to sit down at the keyboard and he can reproduce ten-million-fold—and thanks to Telstar a hundred-million-fold—the picture he is in the process of creating, one finds oneself confronted with a phenomenon of such proportions . . .'.etc.

These are stirring words. Tremendous things are happening on every front. They are happening in painting too. Only they are harder to see, harder to pin down. It is much easier to pronounce art dead and offer (not to the people but to society; the mass of the people, regardless of what may happen, remains blind to art) a whole new art which is exclusively decorative. So .make those colours blaze, keep those lights moving, and let kinetic art and its train of neon set all the jolly colours of the city dancing! Three rousing cheers!

But this 'socialization' business is a myth, a play on words. In actual fact what they want us to swallow as 'art in life' is simply the large-scale industrialized manufacture of a lot of pre-fabricated decoration that has nothing whatever to do with art. 'Art in Life' is merely a matter of good taste in geometry.

Why pretend to be hurling a challenge at bourgeois society when you are just as busy keeping its galleries and industries supplied as anyone else?

At the Paris *Biennale* there was a space that needed something in it.

'It was decided to place there a new work by Le

Parc using the principle of small squares multiplied in front of a surface. . . The wall was more than twenty metres long by six metres high. Le Parc put a certain number of squares in place and it was subsequently discovered—although it was known that the thing was going to occupy the space, no one knew exactly how—that with two thousand-watt lights on it the whole thing worked like a mirror and threw beams of light right across the esplanade between the two museums. The result was a quite exceptional occupation of space. . .' (Frank Popper).

Why not? But what has this combination of little squares and electricity got to do with art being dead?

The truth is rather different. The truth is that techniques of reproduction are improving, that high-quality art products are being turned out in quantity, and that urban decoration is in process of modernization. The market is being expanded and a fresh market created. The consumer society is evolving *its own* arts.

As for 'democratizing' art, that is quite another problem. The curious thing is that the 'Art is dead' cry of May 1968 should have found this response in industry. The extraordinary thing is that behind all the 'Fuck art' slogans (so very much bound up with quite other problems involving a universal rejection of culture) stand enormous organizations in the fields of architec-

ture, the museums, electronics, and the manufacturing industries.

Why not, though? All right, but then let them drop this pretence of being disgusted with the world of commerce.

Who commissions these large-scale works of modern art and anartism anyway? Who blows up these little sculptures and gadgets to the size of mastodons? Industrialists, of course. Who the hell else could afford to? Under the banner of anti-speculation it has become increasingly common for artists to work for large firms.

If this is inevitable, then it would be better to protest a little less noisily against the art object as object of speculation. Because in actual fact what they are demolishing is not society, not at all. It is art.

No, none of this can ever have anything to do with art. These are means of decoration, industrial means, and, as such, of the very greatest importance. And the men who practise them, the men who have raised them to this elevated level, who have got them used, who have made innovations on the frontiers of and even within science—these men are (in the cinematographic sense) *great directors*. But they cannot begin to supplant the real creators in the field of art. They can only be masters in their own field.

Art has nothing to do with this kind of jostling for position. Art is not a gesture. Creative artists in painting and sculpture lack this taste for theatre, for the object as such, for staging spectacles. They are incapable of devoting their entire lives to the manufacture of circles, squares, colours, and harmony. It is not their 'scene'.

Nor is this the real question. The real question, the real point at issue here is a generalized and militant campaign to dehumanize art in favour of mere mindless technique. This is the only problem, the only danger, the only—and monstrous—decadence.

Social art is not a matter of multiplication and dissemination. Painting is not a magic lantern. While some attempt to project ideas into nothing or claim to find them there, others seek to enthrone the vacuum of thought. The result is the same.

Why? Is painting so dangerous that its presence constitutes a threat?

Unlike kinetic art and neon, which are hardly ever mediocre, painting covers both extremes, from the most sublime to the most disastrous, from the corniest daub to the wonder of wonders, from a sunset over the Mediterranean to a *Self-portrait of the Artist with Severed Ear.* The best is scarce, the great in short supply. There is more bad than good, and among the multitude of artists there are few of true stature.

When we speak of art it is this immense

harvest we are thinking of, this vast quantity of works of all kinds among which here and there will be something of quality. Art is the most hide-bound tradition and the most lunatic daring; it is inanity and genius, brute violence or gentle sweetness.

Art—the kind that lives on and will continue to live, the kind that is recognized and the kind that perhaps still awaits recognition, the kind that pursues its search in realms one may or may not have eyes to see—this is one of the major modes of expression of human thought and has been through the centuries the most powerful, the most constant, and the most controversial witness to that thought. It is a conquest of the mind.

And what characterizes all the various anti-art movements today is this need to deny that art has any importance at all.

In the USSR painting and sculpture are governed by the official trends. The kind of freedom in which different tendencies might confront one another is lacking there. Bold experiment remains confined to the privacy of the studio. Alas, a familiar state of affairs.

Art is the born enemy.

On the other hand, and entirely naturally, there exist in the USSR powerful and unrestricted kinetic and neon art movements.

(Incidentally, things are quite different there—less empty.)*

In the manifesto of the Moscow kinetic art group, *Dvijenie*, we read: 'The new kind of art is the product of the collective. We are about to create together an art such as none of us would be in a position to create alone.' But this art results in a blend of various things, in collective productions 'with complex intervention of light-projections, music, shouts, mechanical and human movements. . .'

The group enjoys the patronage of the Scientific Institute for Atomic Physics.

Nusberg has plans for large-scale kinetic productions. He has the backing of men of science. But above all *he and his group, in staging their mammoth productions, receive ideological and financial backing from the state.*

Artists in this field are exempt from the kind of suspicion, domineering interference, irresponsible criticism, hatred of possible Western support, and lack of experience of creative freedom and its needs that makes Russian artists, writers and musicians so lonely, surrounding them with a climate of mistrust which is prejudicial to any kind of fertility of ideas.

It was with every official sanction that these kinetic artists worked on their 'crucial fifteen hundred metre-long project for animating the

* The information and quotations in this passage are taken from Jiri Padrta's article, 'Nusberg, light and movement,' in *Opus*, no.4, and from R.J. Moulin, *op. cit.*

Nevsky Embankment in connection with the cele-
brations for the Fiftieth Anniversary of the October
Revolution.'

It is painting and sculpture that are kept in
chains. Movement and neon not at all.

And the reason is that painting amounts to
something more than these.

This is of course only a brief resumé of what is
happening in the art and non-art worlds. It is
impossible to cover everything. (Had I yielded to
impulse I would have quoted the catalogue of the
1967 Venice *Biennale* practically in full. It is a
classic.)

And meanwhile the painters and sculptors look
on in silence while their life and livelihood are thus
massively called into question in a campaign
conducted in the main by the critics but supported
by all the media—cinema, radio, television—and
backed up by official circles, the museums, and
the entire press.

In the face of this colossal attempt to demolish
art by means of the ubiquitous square, nothingness,
and the whole anartist spectacle, art is content
simply to exist.

That aside, the only possible conclusion to be
drawn from this rapid and incomplete sketch is
this:

You have anti-art and you have the anartists. You have one great merry-go-round of ideas. You have kinetic art. You have what you will.

And you also have painting and sculpture, with or without easel.

And if the whole lot can live and flourish amid the traditional medley of ideas, definitions, sciences, arts, technologies, public spectacles, clowning, meditation, and word-drunk critics wielding vocabularies loaded with or emptied of all meaning, amid the tangle of conflicting schools of thought— then that is fine. That is what freedom means.

But it will only be on condition that a spade is called a spade. Not by carrying polemics into industry, and seeing the heritage of Rembrandt in a square, a flash, or a nana.

As for 'art and society', that is another story altogether.

76